Monet

A THOMAS NELSON BOOK

First published in 1993 by Thomas Nelson Publishers, Nashville, Tennessee.

Copyright © 1993 by Magnolia Editions Limited

10 9 8 7 6 5 4 3 2 1

Library of Congress Cataloguing in Publication Data is available.

Library of Congress Card
93-83510

ISBN 0-7852-8302-1

MINIATURE ART MASTERS
IMPRESSIONISTS: MONET
was prepared and produced by
Magnolia Editions Limited,
15 West 26th Street, New York, N.Y. 10010

Editor: Karla Olson
Art Director: Jeff Batzli
Designer: Susan Livingston
Photography Editor: Ede Rothaus

Printed in Hong Kong and bound in China

Monet

Gerhard Gruitrooy

NELSON REGENCY
A Division of Thomas Nelson, Inc.

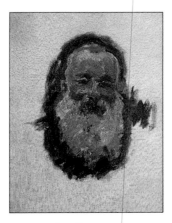

SELF PORTRAIT
1917; OIL ON CANVAS;
27 ½" × 21 ⅝" (70 × 55 CM);
MUSÉE D'ORSAY, PARIS

INTRODUCTION

Claude Monet is considered by many to be the leader of the Impressionist group. In fact, it was his painting *Impression: Sunrise* that gave the movement its name following the ironic labeling by an unfavorable critic who saw the painting at the first Impressionist exhibition in Paris in 1874. Monet was the most ardent supporter of open-air (*en plein air*) painting, directly and immediately recording the colors and atmosphere surrounding the form that the eye sees. His friend and fellow painter Paul Cézanne summarized Monet's approach with these famous words: "Monet is no more than an eye—but, my God, what an eye."

Monet was always a pragmatic and intuitive artist who pursued his career on an individual and often

lonely path. He spent much time painting in the open air, studying the way that the surface color of objects and even shadows modulate under the influence of reflecting light and neighboring colors. He laid on short, fragmentary brushstrokes using pure colors (red, yellow, blue) against their complementaries (green, violet, orange). Following his observation that high key colors appear closer to the eye than darker tones, Monet created space and depth through recession of colors and accurate aerial perspective. The objects almost dissolve in the light that seems to be the real subject of his paintings.

Monet was born in Paris, but spent his childhood in Le Havre. There he met the landscape painter Eugène Boudin, who encouraged him to render atmospheric effects of landscapes as accurately as possible. Later Monet went to study under the painter Charles Gleyre

in Paris, in whose studio he met Camille Pissarro, Auguste Renoir, Frédéric Bazille, and Alfred Sisley. Together the young artists went to paint directly from nature in the forest of Fontainebleau outside of Paris. Here their palette lightened to more accurately reflect atmospheric conditions.

Following Pissarro's suggestion, Monet visited London to avoid the draft during the Franco-Prussian War (1870–1871). In London, he studied the works of John Constable (1776–1837) and Joseph Mallord William Turner (1775–1851), whose interest in atmospheric renderings had preceded his own. Here he began to make his first studies of the Thames River, a subject of a long series later in his career. He also met the art dealer Paul Durand-Ruel who like Monet had sought refuge in London and who had a seminal influence on the whole Impressionist movement.

When he returned to France, Monet first rented a house in Argenteuil, but eventually settled in Giverny in 1883. There he installed his famous garden, including the waterlily pond that became one of his favorite subjects. He traveled several times to the coast of Brittany, and from the 1890s onwards he concentrated on several series of paintings with the same subjects: poplars, haystacks, the cathedral of Rouen, and the Thames river in many variations. His principal preoccupation was to render the changing atmosphere of the scene and the shifting colors.

Monet's first wife, Camille, died in 1879 at age 32, leaving behind two children. A second marriage in 1892 to Alice, the wife of his longtime friend and patron Ernest Hoschedé, who had died a year earlier, finally resolved an embarrassing relationship between Alice and Monet that had begun 15 years earlier. Alice

died in 1911. Toward the end of his life Monet became increasingly blind, but with the support of his stepdaughter, Blanche Hoschedé, he did not stop working. During the years of World War I, in fact, he created his most sublime paintings—a series of waterlilies inspired by his garden. These enormous canvases are a whirl of vibrant colors, and their degree of abstraction—recognizable forms almost disappear—have been seen by some as a precursor of abstract art. The canvases were eventually donated to the French state as his contribution to the restored spirit of peace after World War I. One should not forget, however, that the starting point for Monet was always the direct observation of nature, which he approached with a sensitive and almost scientific eye.

WOMEN IN A GARDEN

1866; OIL ON CANVAS;
100 ³/₈" × 80 ³/₄" (255 × 205 CM);
MUSÉE D'ORSAY, PARIS

The model for all four women was Monet's companion and future wife, Camille. Because it was painted outdoors *(en plein air)* at Ville d'Avray and Honfleur, the work was considered revolutionary as compared to contemporary salon painting. In order to reach the upper part of this large work Monet dug a trench in the ground in which he would sink the canvas, a procedure he learned from the painter and "founder" of Realism, Gustave Courbet. The white dresses reflect bright spots of sunlight and contrast with the darker green tones of the garden.

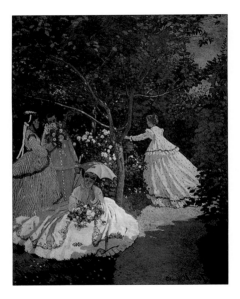

Terrace at Sainte-Adresse

1866–1867; Oil on canvas;
38 ½" × 51 ⅛" (98 × 130cm);
Metropolitan Museum of Art, New York

This is the picturesque terrace of the family's house at Sainte-Adresse, a suburb of Le Havre on the coast, where Monet's parents had moved in 1845. The people in the picture are members of the family. The man in the chair is Monet's father, who had encouraged his son to study painting, but who had withdrawn his financial support after a violent discussion some time before this painting. The high point of view, the sparkling light with its patterns of color spots, and the atmosphere and breeze of the ocean are all elements of Monet's later style.

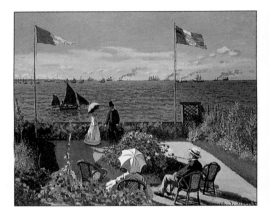

PORTRAIT OF MME. LOUIS JOACHIM GAUDIBERT

1868; OIL ON CANVAS;
85" × 54 ¼" (216 × 138CM);
MUSÉE D'ORSAY, PARIS

In order to escape the persecution of his creditors,
Monet left his companion Camille with their son
Jean behind at Fécamp on the coast of Normandy,
where he had intended to spend the summer
months of 1868. He moved to nearby Etretat,
where he met the businessman Gaudibert. The
businessman bought some of his paintings and
commissioned this life-size portrait of his wife. The
artist's concessions to official formulas notwith-
standing, Monet painted a portrait in which the
disparate luxuries of the Second Empire are ren-
dered with great subtlety and harmony.

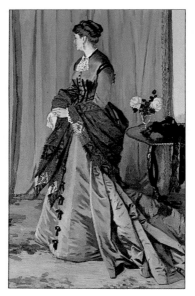

HOTEL ROCHES NOIRES AT TROUVILLE

1870; OIL ON CANVAS;
31 $\frac{7}{8}$" × 23" (81 × 58.5 CM);
MUSÉE D'ORSAY, PARIS

After their wedding on June 26, 1870, Claude and Camille Monet left for Trouville on the coast of Normandy, by then already a preferred region of the artist, who appreciated its atmosphere and quality of light. The luminous colors and the rapid brushstrokes of the flags floating in front of the beach hotel bring to mind those in the *Terrace at Saint-Adresse* (see page 12). This work belongs to Monet's transition period, during which he overcame the monochromatic legacy of realists such as Courbet and established the colorism of *plein air* painting.

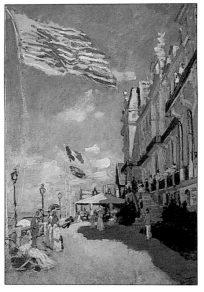

CAMILLE MONET ON THE BEACH AT TROUVILLE

1870; OIL ON CANVAS;
15" × 18 ⅛" (38 × 46CM);
MUSÉE MARMOTTAN, PARIS

The woman with the hat sitting casually on a chair is Camille Monet, who married the artist that summer. Behind her is a cousin with a similar blue striped beach dress apparently reading. The two women, boldly placed close to the picture plane, rhythmically divide the composition. The background rapidly recedes, drawing the viewer's eye to the other guests, who are delighting in typical beach activities. Monet's vision of nature as a counterpart to the harsh urban life has already found its expression in this scene.

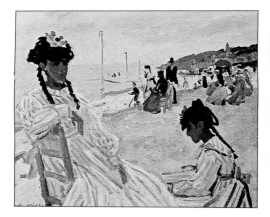

View of Zaandam

1871; Oil on canvas;
18 ⅞" × 28 ¾" (48 × 73 cm);
Musée d'Orsay, Paris

On his way back from London, where he had
taken refuge during the Franco Prussian War
(1870–1871), Monet traveled through Holland,
where he painted this view of the city of Zaandam.
The immense sky and the low horizon show the
influence of Dutch landscapes. Two thirds of the
painting consists of water and sky, but there is no
sense of repetition or boredom. The muted colors,
which perfectly capture the light and atmosphere
of the location, are an indicator that the painting
was executed outdoors.

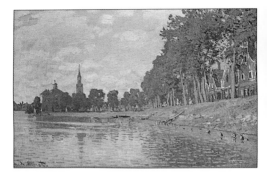

TRAIN IN THE COUNTRY
CIRCA 1870; OIL ON CANVAS;
19 ⅝" × 25 ½" (50 × 65CM);
MUSÉE D'ORSAY, PARIS

Fascinated by modern transportation, Monet repeatedly painted trains and train stations (see pages 44 and 54) throughout his lifetime. Nature and technology are not seen as a contradiction but as part of a single, inseparable visual experience. Monet particularly loved the smoke and steam coming from the engines since they created the misty quality of light that he tried to imitate in many of his works. Here, however, the bright sunlight of a beautiful day in spring or summer prevails and the green grass is unaffected by the blackening smoke.

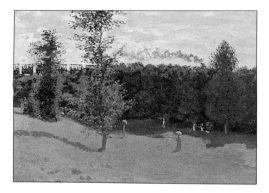

Camille Monet on a Couch
1871; Oil on canvas;
18 ⅞" × 29 ½" (48 × 75 cm);
Musée d'Orsay, Paris

Camille is caught during a moment of relaxation on the couch taking a break from the book she is still holding on her lap. Her face turned toward the window, her thoughts seem to wander. Areas of light and darkness are carefully balanced: there is a subtle balance between the dress and the couch on the one hand and the curtains on the other. Any superfluous decor has been avoided. Compared to the portrait of Mme. Gaudibert painted only three years earlier, the concentration on essentials is striking. The interior is probably Monet's apartment in Paris.

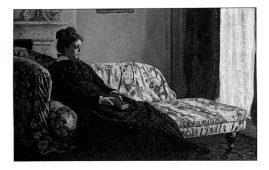

IMPRESSION: SUNRISE

1872; OIL ON CANVAS;
18 ⁷⁄₈" × 24 ³⁄₄" (48 × 63 CM);
MUSÉE MARMOTTAN, PARIS

On April 25, 1874, two years after the completion
of this painting, the first independent exhibition of
the future Impressionists, which included works
by Cézanne, Degas, Monet, Morisot, and Renoir,
among others, was opened in the studio of the pho-
tographer Nadar. Monet's title for this work lent the
new movement its now well-known name, after a
critic ironically labeled the artists as "Impression-
ists," referring to this picture. An early morning hour
at the harbor of Le Havre was the inspiration for
this poetic interpretation.

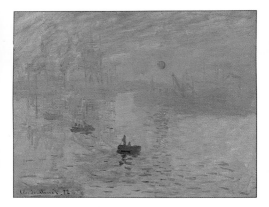

THE DOCK AT ARGENTEUIL

CIRCA 1872; OIL ON CANVAS;
23 ⅝" × 31 ¼" (60 × 80.5CM);
MUSÉE D'ORSAY, PARIS

Because he constantly searched for new impressions, Monet was once called "a hunter, rather than a painter." Argenteuil, a boating resort town about 50 miles (80km) west of Paris on the Seine river, seemed to offer an endless supply of subjects to the artist. The basin is framed by an avenue of trees, and strolling Parisians on their Sunday excursions mingle with the white sails of the boats. The low horizon accentuates the flatness of the locale and echoes Monet's experience with Dutch painting.

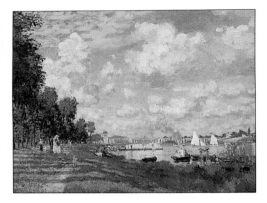

LUNCHEON IN THE GARDEN (MONET'S GARDEN AT ARGENTEUIL)

CIRCA 1873; OIL ON CANVAS;
63" × 79 ⅛" (160 × 201CM);
MUSÉE D'ORSAY, PARIS

Concluding a subject that Monet had treated several years before, this combination of a still life and an outdoor scene shows the great sense of intimacy the artist felt toward his own house. On the ground next to the table Monet's son, Jean, plays with some toys. One of the two women in the background is most likely his wife, Camille. But the main focus of the painting is the atmospheric rendering of garden flowers, of the still life in the foreground, and of the light that pervades the garden.

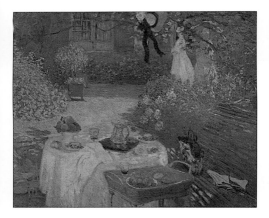

THE CART (SNOW-COVERED ROAD AT HONFLEUR)
CIRCA 1867; OIL ON CANVAS;
25 ⅝" × 36 ⅜" (65 × 92.5 CM);
MUSÉE D'ORSAY, PARIS

The road covered with snow naturally divides the space of the painting. Seen from a distance the cart is trying to make its way through these difficult weather conditions, to which Monet was attracted many times. The work still has a realistic feeling, but under its surface it is already imbued with an impressionistic vibrancy. The city of Honfleur is located at the mouth of the Seine river, across the bay of Le Havre, where Monet spent his entire childhood.

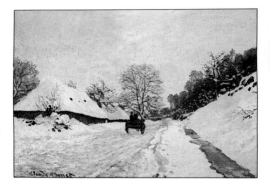

THE MAGPIE

1872; OIL ON CANVAS;
34 ⅝″ × 51 ¼″ (88 × 130 CM);
MUSÉE D'ORSAY, PARIS

In the lifeless cold of snow and ice the only living creature is the magpie resting on the gate of a garden. This symphony in white is animated by shadows cast on the white ground by a late afternoon sun and by the wall dividing the picture into two horizontal parts. Unlike Renoir, who called snow "a kind of a mildew on nature's face," Monet was fascinated by this phenomenon and depicted it on many occasions.

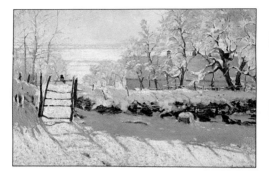

MONET **35**

CARNIVAL ON THE BOULEVARD DES CAPUCINES

1873; OIL ON CANVAS;
23 ⅝" × 31 ½" (60 × 80 CM);
PUSHKIN MUSEUM, MOSCOW

The annual carnival parade was one of the most popular festivals of the year in Paris. Colorful decorated carts and people dressed up in costumes filled the boulevards. On the right, cut off by the edge of the painting, two gentlemen in top hats and black frocks are watching the event. The artist himself was watching from the window of an apartment a safe distance away. The figures buzzing about the street are captured with quickly painted dots of color. This painting was exhibited at the first group show of the future Impressionists (see also page 26).

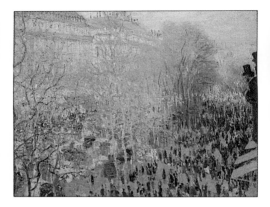

Rest under the Lilacs

1873; Oil on canvas;
19 ¾" × 25 ½" (50 × 65cm);
Musée d'Orsay, Paris

This work illustrates particularly well the Impressionist theory that colors become paler under the exposure of sunlight. Large, vigorous brushstrokes of thin paint illuminate the pink petals of the lilac tree under which a group of three people, two women and a man with a black hat, are sitting on the grass. The central figure of the woman, who wears a light summer dress, can be more easily distinguished from the dark shadows than the other two.

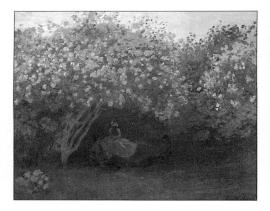

FIELD OF POPPIES

1873; OIL ON CANVAS;
19 ³/₄" × 25 ½" (50 × 65 CM);
MUSÉE D'ORSAY, PARIS

One of Monet's most famous paintings, this work
was exhibited at the first Impressionist exhibition
of 1874. It shows his wife, Camille, walking with
a little boy, probably her son, Jean, through a field
of high grass and red poppies. Monet caught this
"impression" at Argenteuil. In fact, there are two
figure groups, one further back on the top of the
elevation, the other in the foreground where
the woman has opened a blue parasol. The two
groups are most likely the same people rendered
at two different moments. The real protagonists,
however, are the poppies.

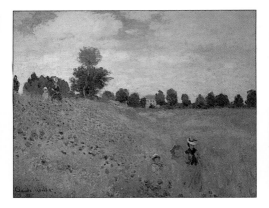

BOATS AND BRIDGE AT ARGENTEUIL

1874; OIL ON CANVAS;
23 ⅝" × 31 ½" (60 × 80 CM);
MUSÉE D'ORSAY, PARIS

Like many other artists, Monet spent the summers at Argenteuil, a town near Paris on the Seine river. The boats, the water, the bridge, and the houses and trees in the back are all merely suggested on the painting's surface. However, they do balance all of the painting's elements. The scene was not chosen at random and should not be considered merely a snapshot. It clearly follows compositional rules of balance and harmony, for example, in the distribution of light and shadow. A critic characterized the painting once as an "aerial geometric structure."

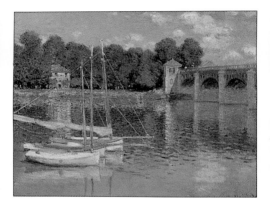

THE LOCOMOTIVE

1875; OIL ON CANVAS;
23 ¼" × 30 ¾" (59 × 78 CM);
MUSÉE MARMOTTAN, PARIS

This is another example of Monet's fascination with locomotives and trains. The smoke from the engine works in harmony with the sky and the snow. The full length of the train is paralleled by the fence and the row of leafless trees has been made visible. The paint has been applied almost flat on the canvas with slight undulations of the material. Bought from the artist by Georges de Bellio, a medical doctor and supporter of the Impressionists, this painting was bequested to the museum by his daughter.

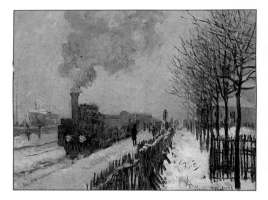

INTERIOR OF AN APARTMENT

1875; OIL ON CANVAS;
32 1/8" × 23 5/8" (81.5 × 60 CM);
MUSÉE D'ORSAY, PARIS

The subject is an unusual one for Monet, but illustrates the variety of his interest. The almost photographic quality of the selected scene has no parallel in the artist's oeuvre. Framed by two palm trees and a curtain bathed in a bright light we look into the interior of a dark room. At the other end, behind a round table, a window connects to the light of the foreground. A little boy in a dark costume, probably Jean Monet, stands at the center of the room. He is almost absorbed by the shadows around him; only his eyes seem to reflect the azure of the light passing through the window.

BOATS ON THE SEINE AT ARGENTEUIL

1875; OIL ON CANVAS;
22" × 25 ⅝" (56 × 65 CM);
ORANGERIE, PARIS

Looking at the bright orange and azure of this painting, one can imagine the fascination the artist must have experienced on an early summer morning in the country. The pure colors seem to echo the innocent joy of that moment. The diagonal movement of the sailboats cutting obliquely across the picture plane ends with a couple standing underneath a poplar tree on the other side of the water. The white poles give the composition the necessary vertical dimension. The bows of the two boats nearest the viewer seem to invite him to head off for a trip.

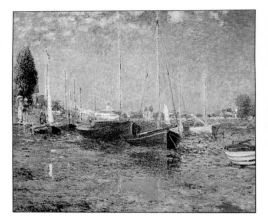

CAMILLE MONET IN JAPANESE COSTUME

1876; OIL ON CANVAS;
91" × 56" (231 × 142CM);
MUSEUM OF FINE ARTS, BOSTON

During a stay in Amsterdam, Monet bought a number of Japanese woodcuts with which he covered the walls of his dining room in Giverny. Like many of his friends, he admired Japanese art, which had become known in the West only after Japan emerged from its century-long isolation. The model for this unusual work was again his wife, Camille, this time seen with blond hair. The sumptuous kimono is decorated with the image of a samurai warrior. Many years later the artist characterized the painting as "simply whimsical." Nonetheless, it was an immediate success and sold for a large sum of money.

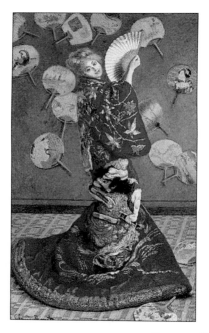

VIEW OVER THE TUILERIES GARDEN

1876; OIL ON CANVAS;
20 7/8" × 28 1/4" (53 × 72 CM);
MUSÉE MARMOTTAN, PARIS

This work was painted from a window overlooking the park adjacent to the Louvre. Waterbasins and paths punctuated by trees and bushes divide the garden rhythmically. Strolling visitors are rendered with briefly dotted color as are the flowering trees that blend smoothly into the painting's surface. In order to give the scene a twist, the composition is slightly slanted, with the house on the left serving as a pillar that holds the space together visually.

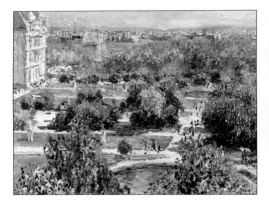

GARE SAINT-LAZARE

1877; OIL ON CANVAS;
29 ¾" × 41" (75.5 × 104CM);
MUSÉE D'ORSAY, PARIS

An homage to the new industrial world of Paris, this painting shows the arrival of a train at the station of Saint-Lazare in full sunlight. The steam of the engine fills the air of the glass-roofed hall while passengers hurry about the platform. One can almost feel the bustling sounds of a station and its whistling locomotives. Monet obtained permission from the station master to spend several days on the platforms making sketches. He was so fascinated by this subject that he painted it a number of times.

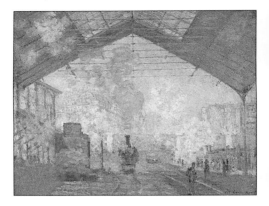

THE TURKEYS
(CHATEAU OF ROTTEMBOURG, AT MONTGERON)
1877; OIL ON CANVAS;
68 ¾" × 68" (174.5 × 172.5 CM);
MUSÉE D'ORSAY, PARIS

The year before he started this painting, Monet
met the financial businessman and art collector
Ernest Hoschedé, whose nearby castle is seen in
the distance, at Argenteuil. The two men became
friends, but eventually Monet fell in love with
Hoschedé's wife, Alice, which caused a particularly
uncomfortable situation. The painting was exhib-
ited twice in an unfinished state and some believe
that it was never completed. Be that as it may,
this image of young, white turkeys contrasting
with the fresh green grass is an extraordinary,
though somewhat peculiar painting.

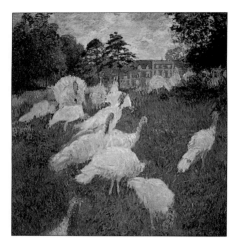

VASE WITH CHRYSANTHEMUMS

1878; OIL ON CANVAS;
21 ½" × 25 ⅝" (54.5 × 65 CM);
MUSÉE D'ORSAY, PARIS

Flower still lifes played only a minor role in
Monet's painting. After some early attempts,
however, he returned to this subject more fre-
quently in the years between 1876 and 1880,
when he sent some canvases to the Impressionist
shows. Chrysanthemums, imported from China at
the end of the eighteenth century, were very
popular during those years. Monet depicted them
loosely arranged in a terra-cotta vase placed
off-center on a counter or table against a light-
blue wallpaper decorated with flower bouquets.

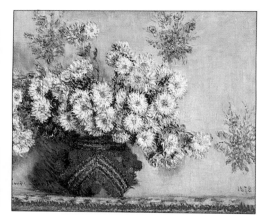

CAMILLE MONET ON HER DEATHBED
1879; OIL ON CANVAS;
35 $\frac{1}{2}$" × 26 $\frac{3}{4}$" (90 × 68 CM);
MUSÉE D'ORSAY, PARIS

Monet once confided to his friend Georges Clemenceau that he had painted a woman on her deathbed while watching the colors of death slowly altering her appearance. To his distress he had responded more to the pictorial challenge than to his own emotions. Monet was referring to the death of his wife, Camille, on September 5, 1879, after years of illness. Covered under a shroud of bed linens she holds a bouquet of withered flowers. The blue, yellow, and gray tones of the picture are those that he had discerned on her face. This almost symbolist spirituality is a striking divergence from Monet's usually sun-drenched world.

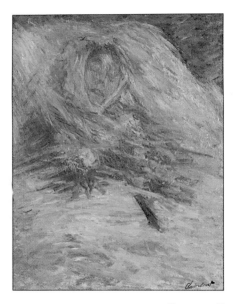

LANDSCAPE WITH MELTING SNOW

1880; OIL ON CANVAS;
23 ⅝" × 39 ⅜" (60 × 100 CM);
MUSÉE D'ORSAY, PARIS

The winter following the death of Camille Monet was an exceptionally harsh one. The town of Vétheuil was isolated by snow and the Seine River completely frozen. But toward the end of the year a sudden thaw created spectacular scenes of ice blocks floating on the water. Attracted by these views, Monet made many sketches that resulted in a series of paintings. Here, at a bend of the river, which is surrounded by shrubs and poplars, the ice is calmly drifting on the surface of the water.

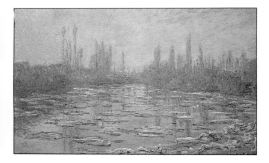

Vase with Sunflowers

1881; Oil on canvas;
39 3/8" × 31 7/8" (100 × 81cm);
Metropolitan Museum of Art, New York

Monet's still lifes are more realistic than his poetic landscapes. His sunflowers in particular have an expressive and decorative effect that van Gogh exploited in his famous paintings of sunflowers at the end of the decade. As in *Vase with Chrysanthemums* (see page 58), the flowers appear as if arranged in a casual way. The bright yellow petals are set against a plain wall of neutral color tones, while the table on which the vase rests is seen from a corner, adding a sense of depth.

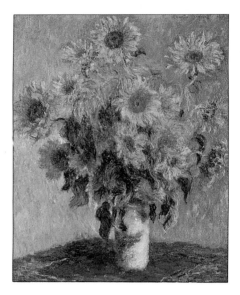

BOATS ON THE BEACH AT ETRETAT

1883; OIL ON CANVAS;
26" × 31 ⅞" (66 × 81CM);
MUSÉE D'ORSAY, PARIS

The sea resort of Etretat in Normandy has the most beautiful cliffs in France. They have attracted many artists over the centuries, among them Delacroix and Matisse. Monet visited the coast during the winter months to capture the dramatic aspects of the site. The writer Guy de Maupassant saw the artist on the beach being followed by some children carrying several canvases, each with the same scene, but painted at a different hour of the day with a different light effect. The asymmetrical arrangement of the present composition might have been influenced by Japanese woodblock prints, which the artist collected.

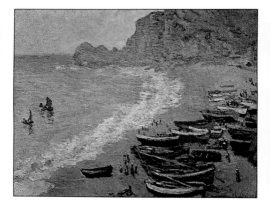

TULIP FIELDS

1886; OIL ON CANVAS;
26" × 32 ¼" (66 × 82CM);
MUSÉE D'ORSAY, PARIS

Testimony of a brief visit to Holland in May 1886, this painting is an homage to the Dutch landscape and its characteristic local flower. The blue sky takes up half of the canvas while the flowers form a chromatic counterpoint. The windmill and the farmhouse add a folkloric note to this symphony in red. This peaceful world does not reflect Monet's personal life at the time; he was troubled by the prospect of leaving his mistress, Alice, the wife of his patron Hoschedé.

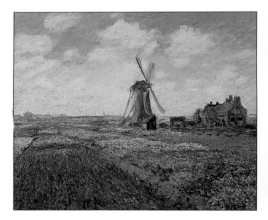

GARDEN IN BLOOM AT SAINTE-ADRESSE

CIRCA 1886; OIL ON CANVAS;
25 ½" × 21 ¼" (65 × 54CM);
MUSÉE D'ORSAY, PARIS

Monet had already captured the fresh and crisp air of the summer at the Channel coast in the solemn *Terrace at Sainte-Adresse* (see page 12). This garden scene, though, could hardly be more modest and casual. Sparkling and buoyant geraniums have been rapidly dabbed onto the canvas as small dots of red, white, and pink. The ephemeral nature of flowers is suggested by the petals that have just fallen on the ground. The adjacent house is concealed in good part by foliage, while a fragment of an uncommonly clear blue sky tops the impression of an accidental snapshot.

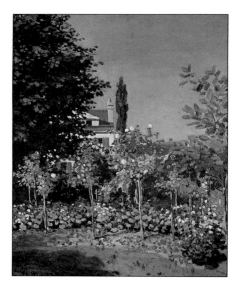

HAYSTACK AT GIVERNY
1886; OIL ON CANVAS;
24" × 31 7/8" (61 × 81CM);
HERMITAGE, ST. PETERSBURG

Horizontal rhythms are repeated in several layers, from the field in the foreground to the group of houses, to the landscape, and finally to the sky. Calmness and contemplation dominates this idyllic rural scene, which is interrupted only by the single haystack. A few years later Monet bought a house and property in Giverny where he spent most of the rest of his life.

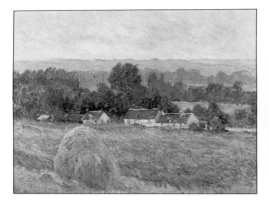

WOMAN WITH PARASOL
TURNED TOWARD THE LEFT

1886; OIL ON CANVAS;
51 ½" × 34 ⅝" (131 × 88CM);
MUSÉE D'ORSAY, PARIS

Seen from a low angle, the woman is taking a walk, probably on the coast of Normandy, protecting herself from the bright sunlight with a parasol. A light breeze is blowing, as indicated by her floating veil and the movement of the grass. The colors are not "realistic," but are rendered as seen through the artist's eyes. In a similar painting with the same model (perhaps Monet's stepdaughter, Blanche Hoschedé), the woman is turned toward the right.

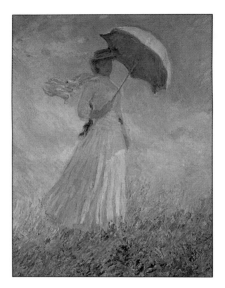

THE BARK AT GIVERNY
CIRCA 1887; OIL ON CANVAS;
38 ½" × 51 ½" (98 × 131 CM);
MUSÉE D'ORSAY, PARIS

The scene looks almost like a photograph so over-whelming is the calmness of the locale. Even the surface of the water is perfectly smooth, reflecting the three women in their boat. The dark green colors evoke the humid atmosphere of the pond, similar to the one Monet created in his own garden at Giverny some years later and in which he planted a large number of waterlilies. This painting is one of the most romantic works in the artist's oeuvre.

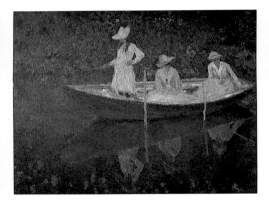

Haystacks, Late Summer, Giverny

1891; Oil on canvas;
23 ¾" × 39 ½" (60.5 × 100.5cm);
Musée d'Orsay, Paris

In the 1890s Monet pursued more intensively than ever a specific aspect of his work, the rendering of light effects. In a series of haystacks, poplars, and finally the cathedral of Rouen (see page 80), he reexamined a single scene over and over. In these cases, his highly refined sense of perception creates a dreamlike quality in the painting that transcends the objects depicted in it. The two haystacks have become a pretense for something more important than the poetic description of a summer landscape. Monet painted this scene at various times of the day, teaching a lesson about how the same image looks under different conditions.

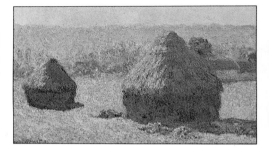

ROUEN CATHEDRAL
(BRIGHT SUN—HARMONY IN BLUE AND GOLD)
1892–1894; OIL ON CANVAS;
42 ⅛" × 28 ¾" (107 × 73 CM);
MUSÉE D'ORSAY, PARIS

Monet had worked on series of canvases with the same subject before, but never had he become as obsessed with a single scene as with the cathedral of Rouen. He painted more than thirty almost identical views of the facade of this monument of French Gothic architecture from a rented room in a house on the cathedral's square. The amplified scale of a close-up view suggests the enormous size of the building, which expands far beyond the picture frame. Monet's goal was to document the ever-changing moments of time.

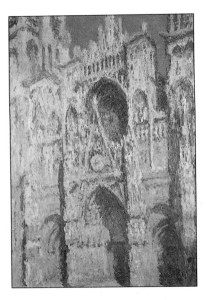

THE PARLIAMENT IN LONDON (PATCH OF SUN IN THE FOG)

1904; OIL ON CANVAS;
31 ⅞" × 36 ¼" (81 × 92 CM);
MUSÉE D'ORSAY, PARIS

"I like London very much, but only during the winter months," Monet once said. It was then that the fog covered the city with a dreamlike, unreal mystery. For three winters in a row, from 1900 to 1903, Monet returned to London to paint the Thames River. Keeping several canvases around him at the same time, he moved from one to the other whenever the changing atmosphere required a different approach to the very same scene. These studies were later elaborated upon in the studio at Giverny, where Monet worked on all of them at the same time.

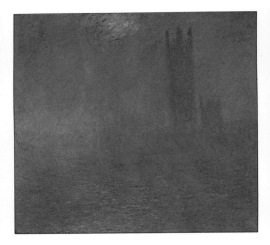

THE ARTIST'S GARDEN AT GIVERNY

1900; OIL ON CANVAS;
31 $\frac{7}{8}$" × 36 $\frac{1}{4}$" (81 × 92CM);
MUSÉE D'ORSAY, PARIS

In 1890 Monet bought the house and garden at
Giverny, which he slowly turned into a floral par-
adise. During his first visit to Giverny a few years
before, the artist had been struck by the beauty
of an orchard in flower and this image was never
forgotten. Here, a sea of purple lilies covers large
areas of the canvas. The slanted angle and the
movement of the quickly applied dots of color lead
the eye into the distance.

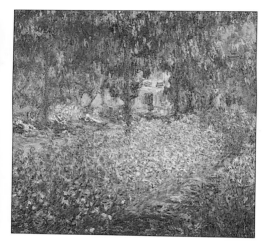

THE WATER LILY POND: GREEN HARMONY

1899; OIL ON CANVAS;
35 ¼" × 39 ⅞" (89.5 × 100 CM);
MUSÉE D'ORSAY, PARIS

One of the famous views of the waterlily pond in Giverny, this painting includes a little bridge reminiscent of such structures in Japanese gardens. Behind it the branches of a weeping willow are hanging down into the water; on the left reeds are lit by rays of sunlight. Again, Monet did various versions of this scene; a different color prevails in each. The present one is dominated by a whole range of greens, hence the subtitle for this work.

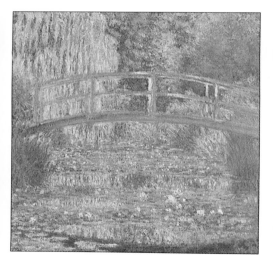

WATERLILIES

1904; OIL ON CANVAS;
35 ½" × 36 ¼" (90 × 92 CM);
MUSÉE D'ORSAY, PARIS

Of similar format and dimension as *The Water Lily
Pond* (see page 86), this painting is a prelude to
what was to become the artist's final pictorial
achievement: the large series of waterlilies, now
preserved in the Orangerie, Paris (see pages 90
and 92). Monet's visual search was not based on
his intellect but on sensations. His message is
therefore the result of inner instincts rather than
rationally controlled expressions.

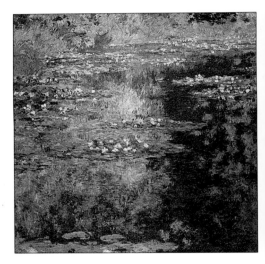

WATERLILIES: GREEN REFLECTIONS

1914–1918; OIL ON CANVAS ON TWO PANELS; 77 1/2" × 333 1/2" (197 × 847CM); ORANGERIE, PARIS

After the death of his second wife, Alice, in 1911 and that of his eldest son, Jean, in 1914, Monet led a reclusive life only rarely interrupted by visitors. Nonetheless, Georges Clemenceau encouraged him to build a new and larger studio, the third one in Giverny. When in 1918 visitors came to see the "enormous and mysterious decorations" on which the artist had been working in secret for so long, they had the impression they were "attend[ing] one of the first hours after the creation of the world." The waterlilies appear as accidental details of a much broader, perhaps infinite continuum.

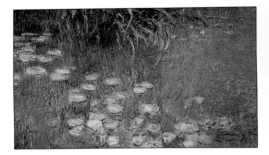

WATERLILIES: SUNSET

1914–1918; OIL ON CANVAS;
77 ½" × 233 ⅞" (197 x 594CM);
ORANGERIE, PARIS

Shortly before his death Monet confessed that he could not sleep because the waterlilies were haunting him in his dreams. The fatigue of endless self-criticism was torturing his artistic confidence. "I work daily on these canvases," he said. Each time light and atmosphere changed, he altered his paintings, to rework the visions he had captured previously. To commemorate the peace after the war, Monet promised to give twelve of these canvases to the French Government; they were installed in the Orangerie of the Tuileries Gardens in Paris.

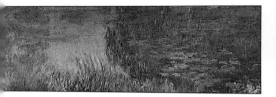

INDEX OF ARTWORKS

PHOTOGRAPHY CREDITS